D1017120

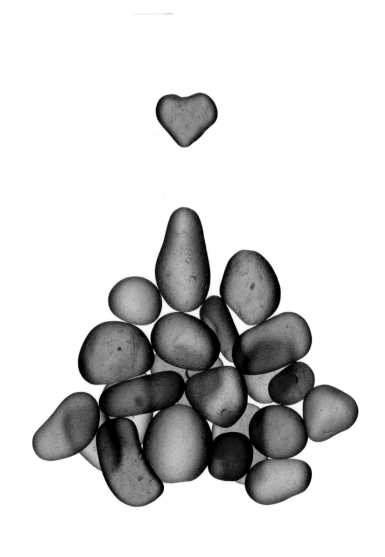

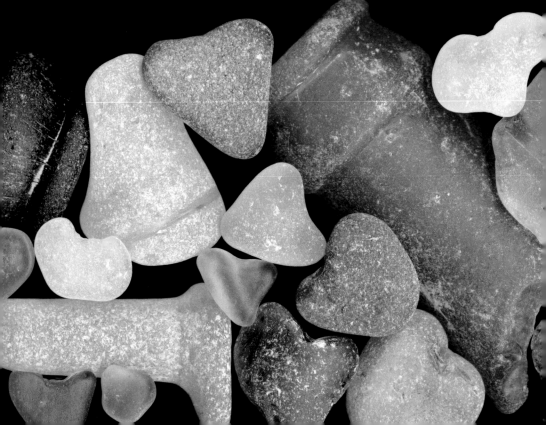

sea glass hearts

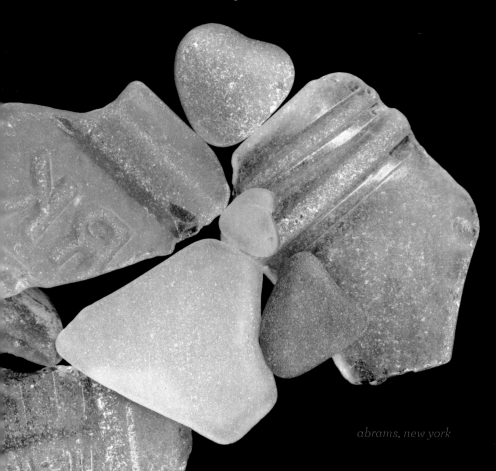

photographs and text by josie iselin

abrams, new york

Designers: Darilyn Lowe Carnes, Josie Iselin
Production Manager: Ankur Ghosh

Cataloging-in-Publication Data has been applied for and may be obtained from the
Library of Congress.

ISBN: 978-1-4197-0218-1

Printed and bound in China
10 9 8 7 6 5 4 3 2 1

Abrams books are available at special discounts when purchased in quantity for premiums and
promotions as well as fundraising or educational use. Special editions can also be created to
specification. For details, contact specialsales@abramsbooks.com or the address below.

ABRAMS
THE ART OF BOOKS SINCE 1949
115 West 18th Street
New York, NY 10011
www.abramsbooks.com

for my mom

whose love and support is the keepsake

I pass on to my children

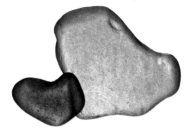

introduction

While "glass heart" implies something fragile and easily broken, those of us who wander the beach and collect sea glass know better. We understand how durable and tough our "mermaids' tears" are—how brilliant and evocative, how worldly and worn. A sea glass heart will not break. It will spread its message with sincerity and joy. It will last forever. When a glint at the water's edge reveals itself to be a sea glass heart, no matter whether startling blue, unheard-of red, or the most common white, we feel blessed.

The heart is an interesting symbol. The shape occurs freely in nature; we find hearts everywhere we look. And yet we cannot help but see them as special, a sign of something out there speaking to us. Glass, and especially sea glass, is also rich in implication. It is a true testament to human ingenuity: to mix quartz sand, soda, and lime, add some color by way of a trace element such as cobalt or copper, and fabricate a useful object. And yet sea glass feels like a natural thing, rendered up to us by

the ocean. It is, in fact, elementally "of the beach," composed of quartz sand, or silica, and carbonate sand, or lime, which is derived from bits of seashells and coral compressed over millions of years into limestone.

As plastic replaces everyday glass, we feel nostalgia for bottles and the stories behind them, collected piece by piece along the shoreline. When one of these frosted shards is a heart, however, this unassuming valentine simply embodies the romance of the beach and is thrust into our pocket with a smile. We can only wonder how the forces of the sea conspired to forge this tiny symbol of love.

love song
for the
beach

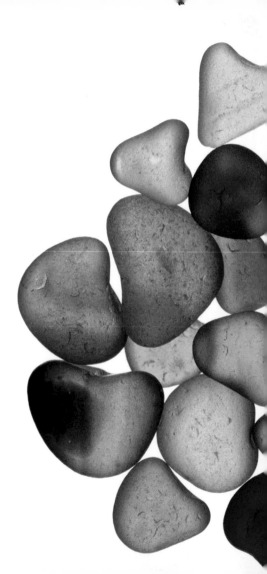

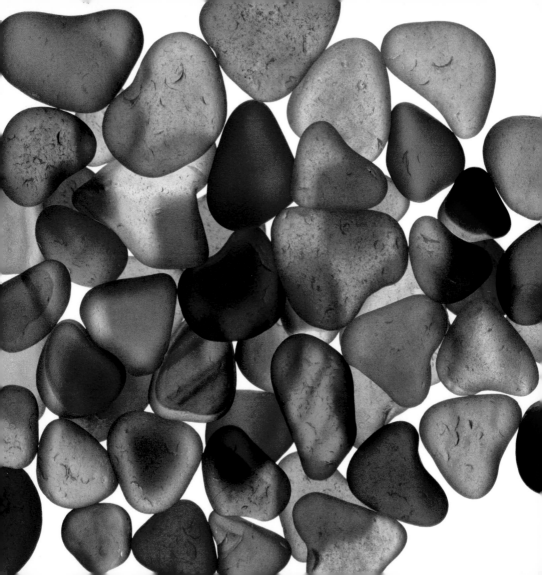

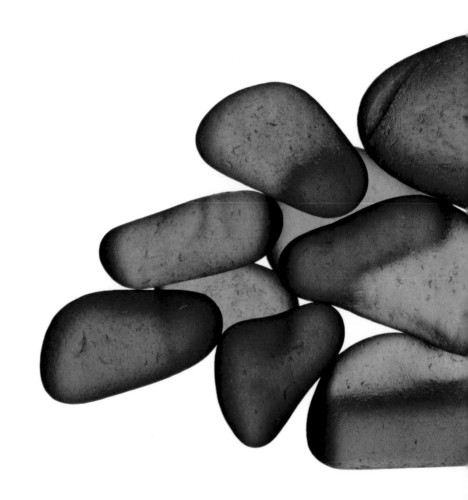

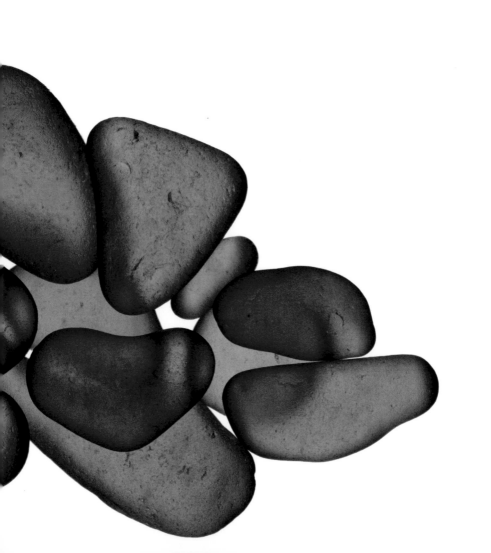

true love
found
at ocean's edge

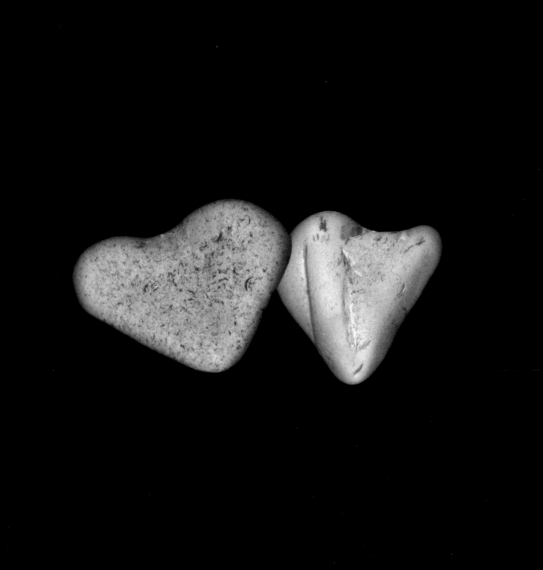

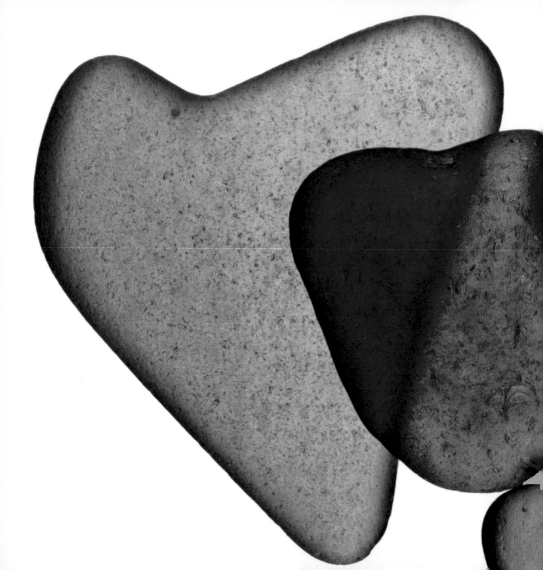

exposed

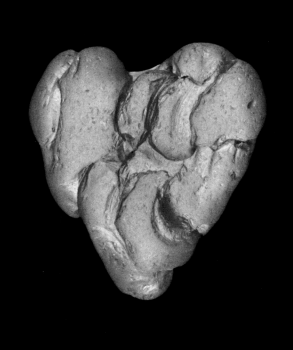

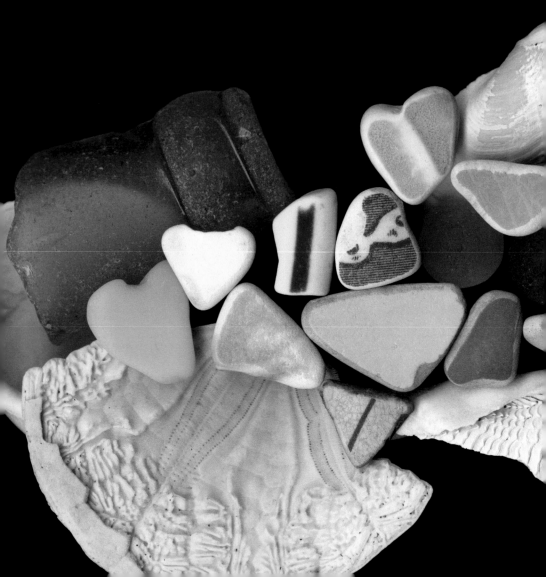

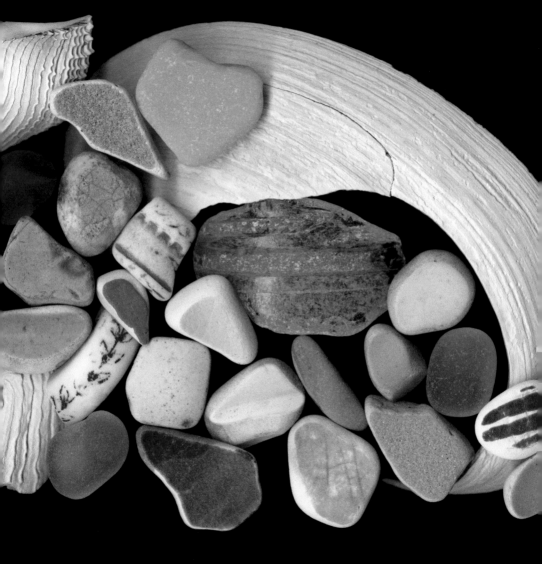

joyful in happenstance

resilient

radiant

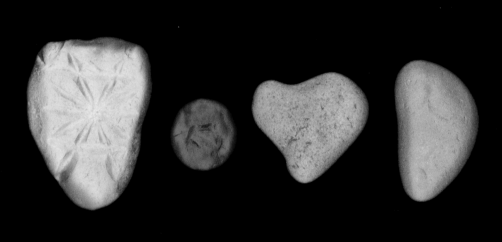

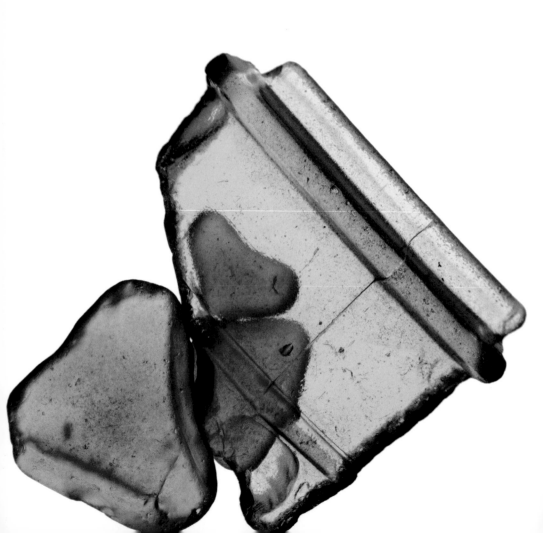

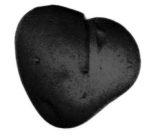

an end-of-day

jewel

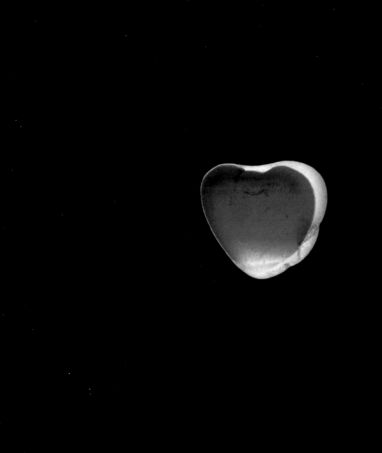

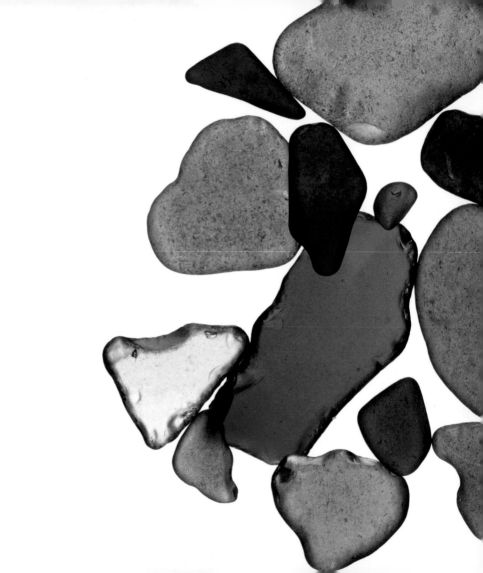

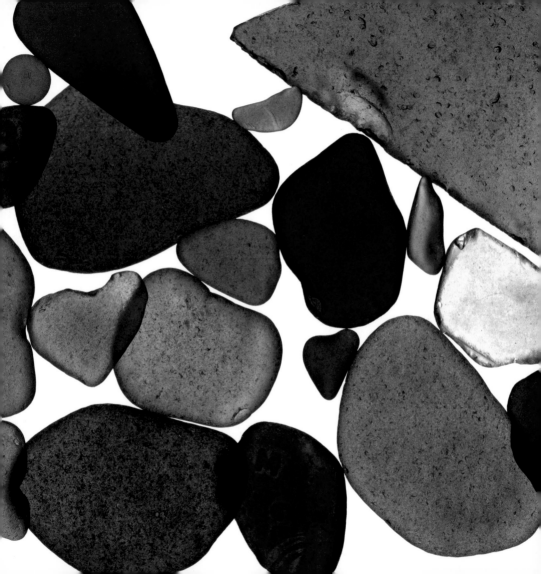

worn by years

infused with the clarity and hope

of each tide

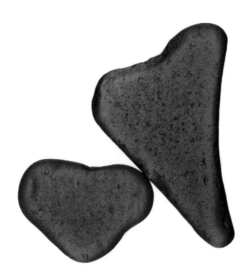

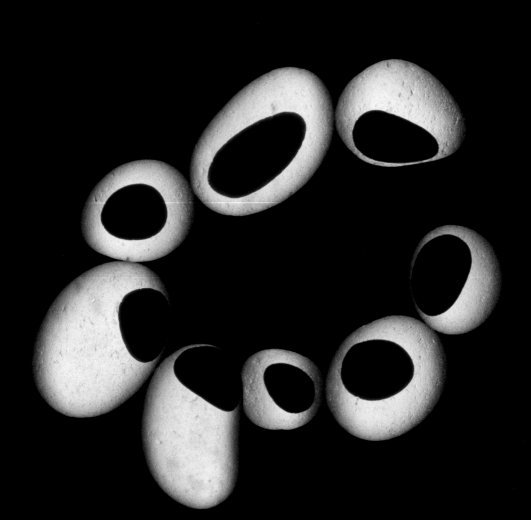

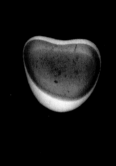

and manganese for white
copper for green
gold for my exalted red

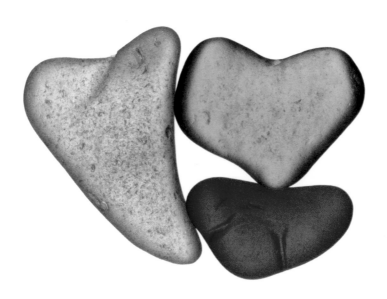

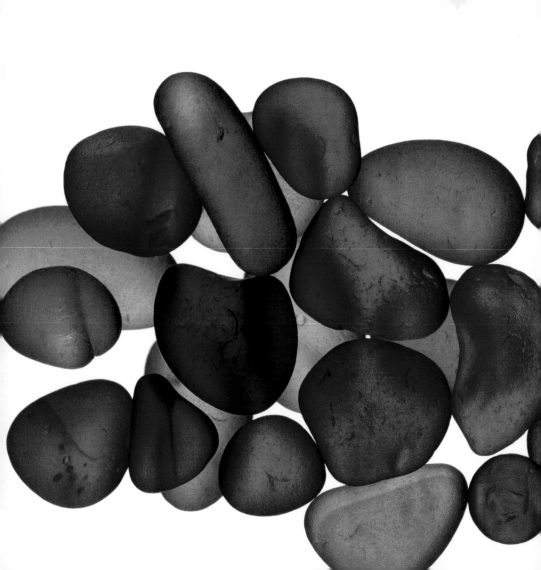

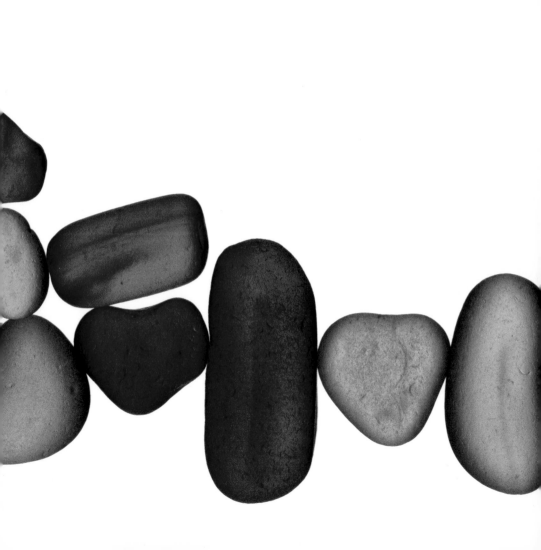

marked by C-shaped scars

a thoughtfulness

abounds

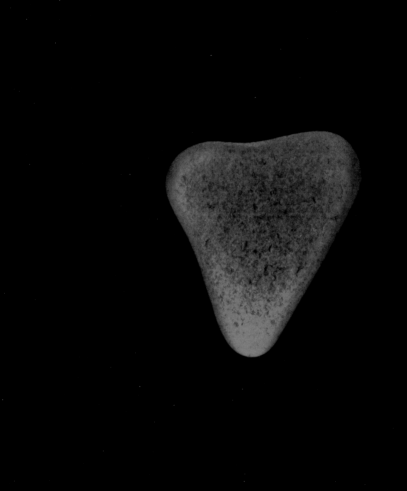

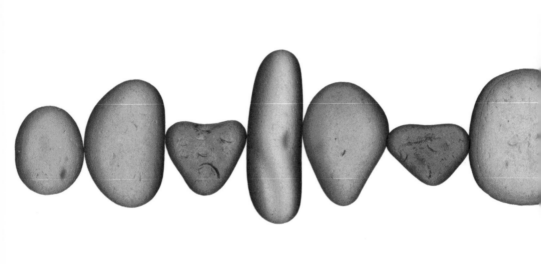

or adventure

spurred by our imagination

our loves

a moon-tide low

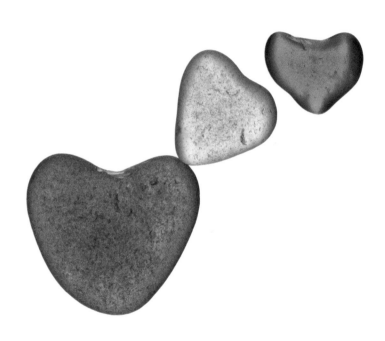

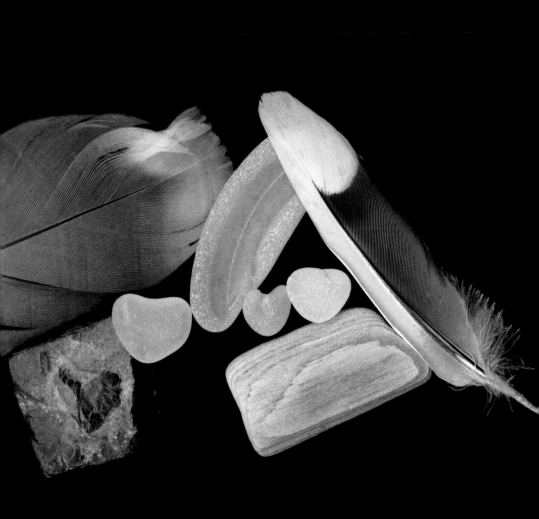

pounding surf
or pure
serendipity

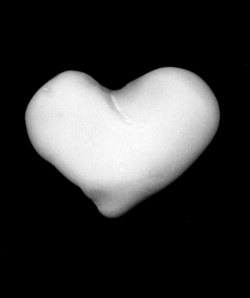

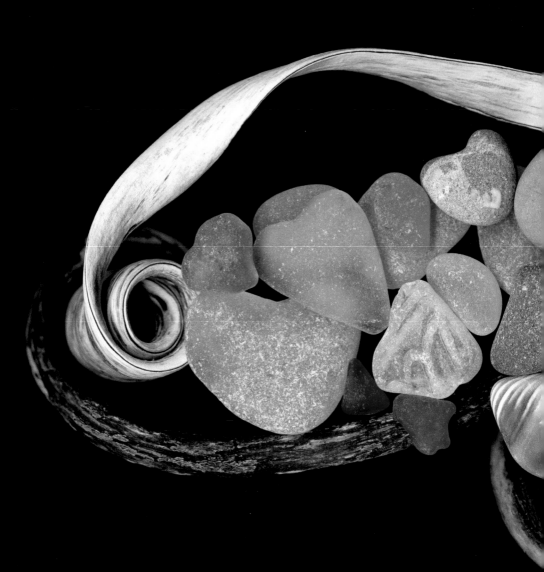

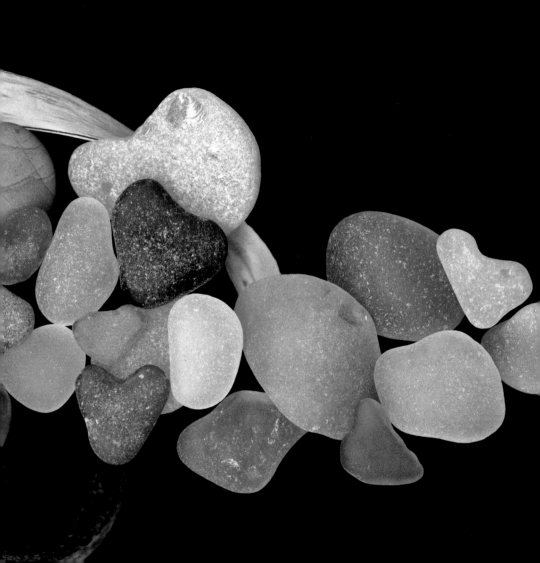

our hold is fragile

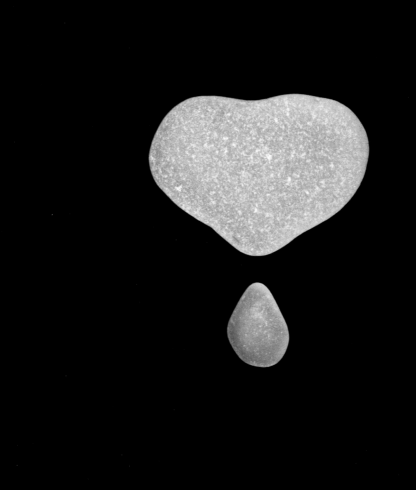

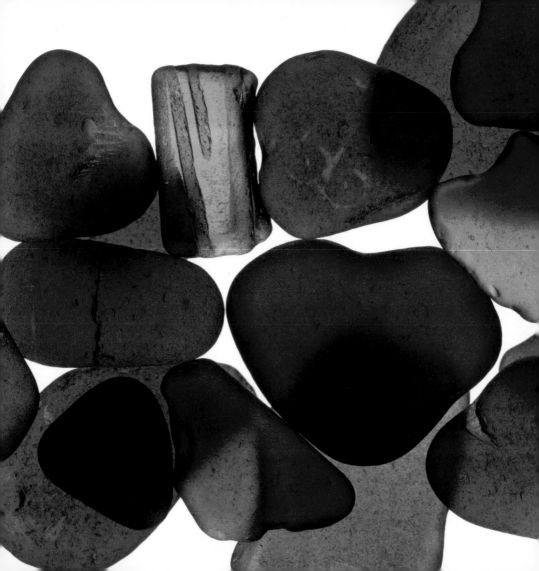

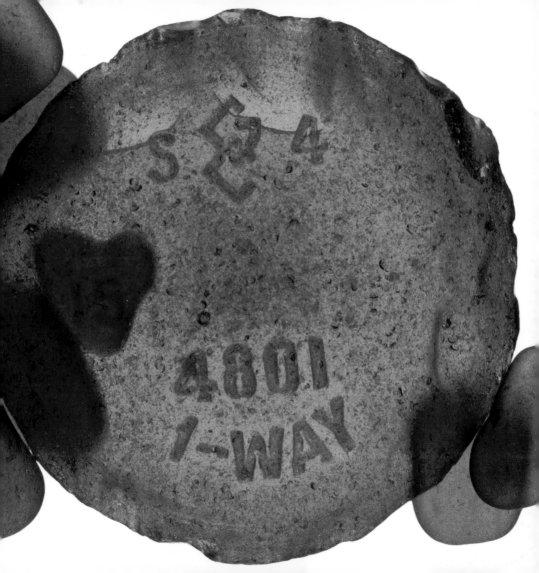

but not this glass
of lime and silica
returning from the sea

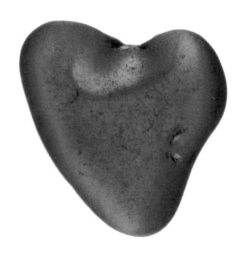

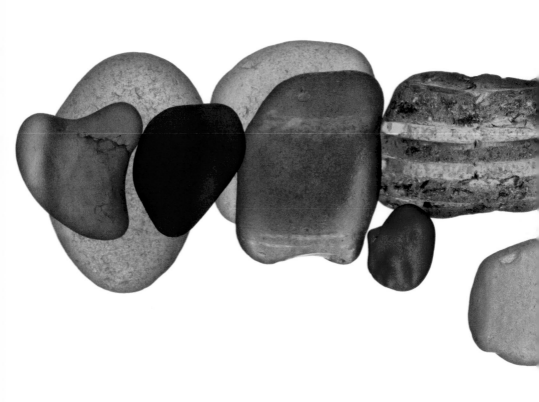

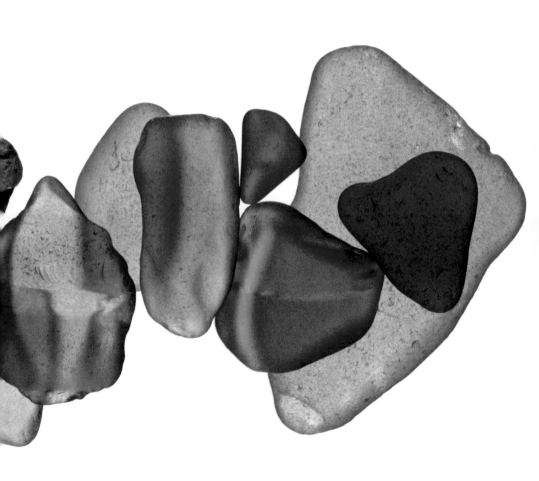

millennia
of crushed shells
mixed back with the beach

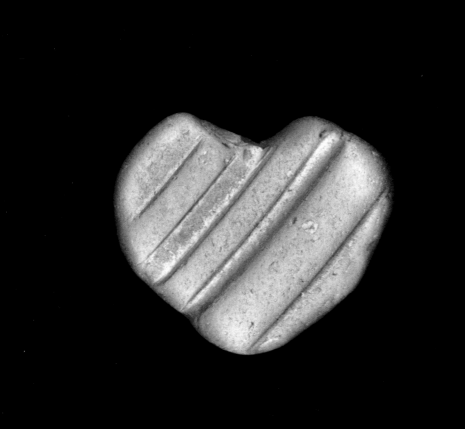

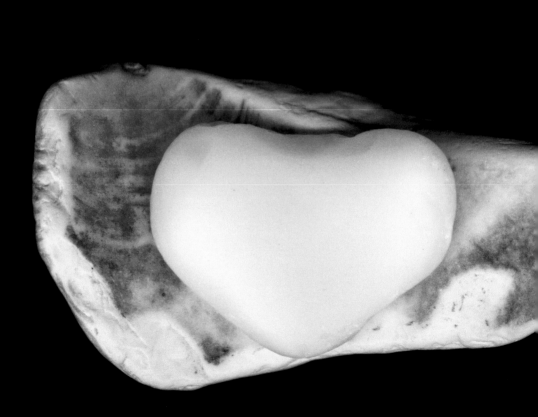

blinking in the tide

as sun

glinting

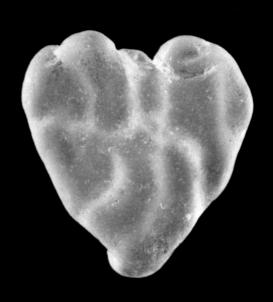

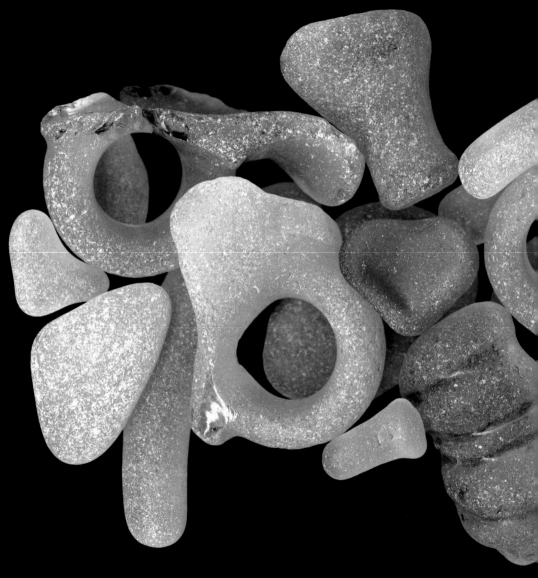

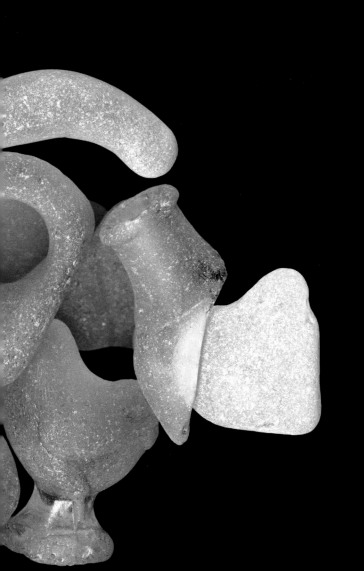

varnished layers
of abalone

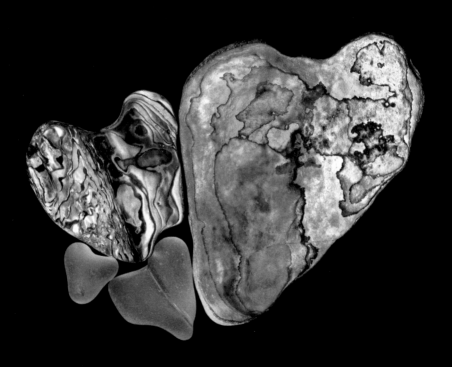

an offering

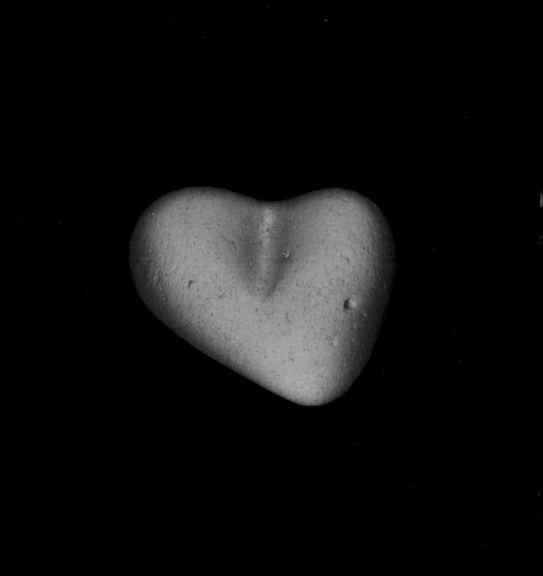

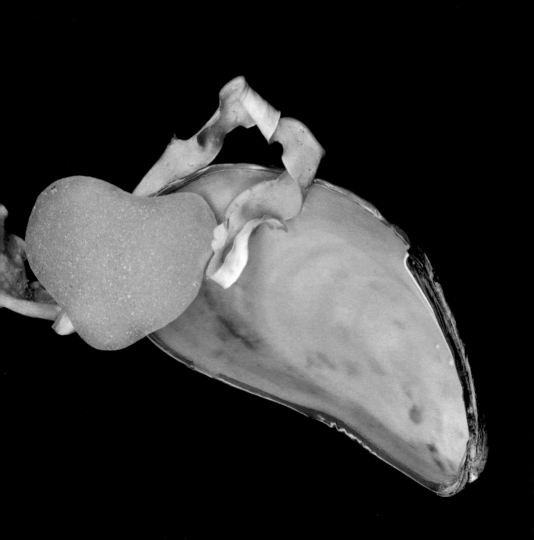

dashed hopes
thwarted desires
unwound

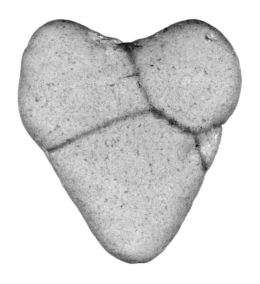

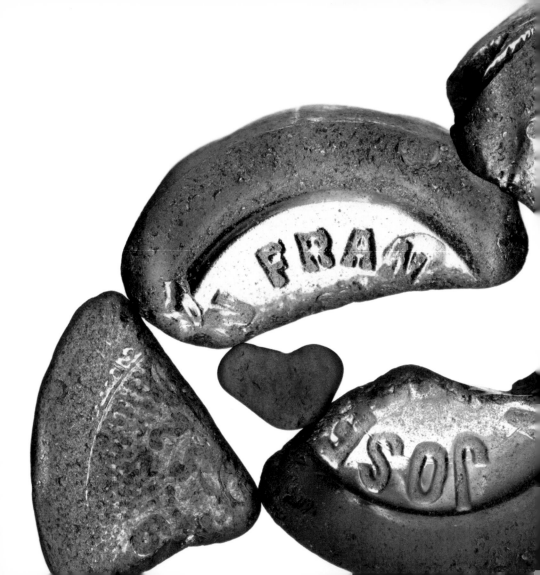

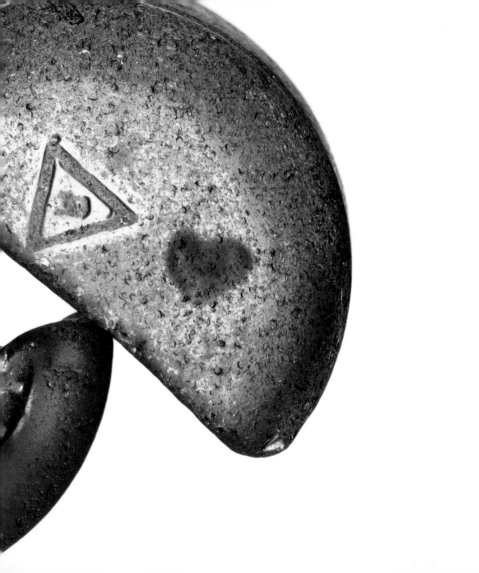

into the spume-frosted token
of our shared delight

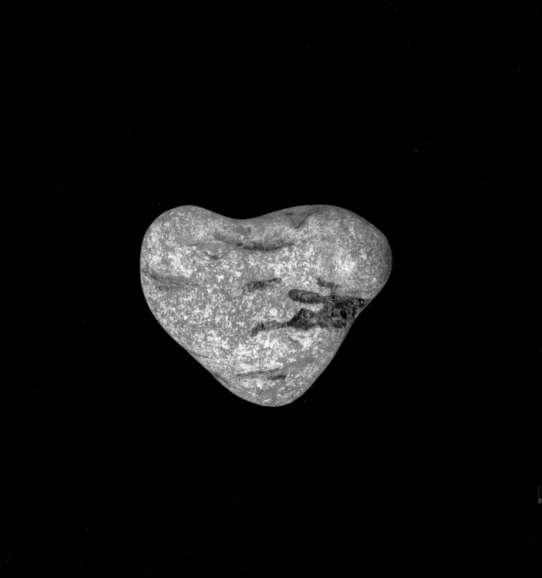

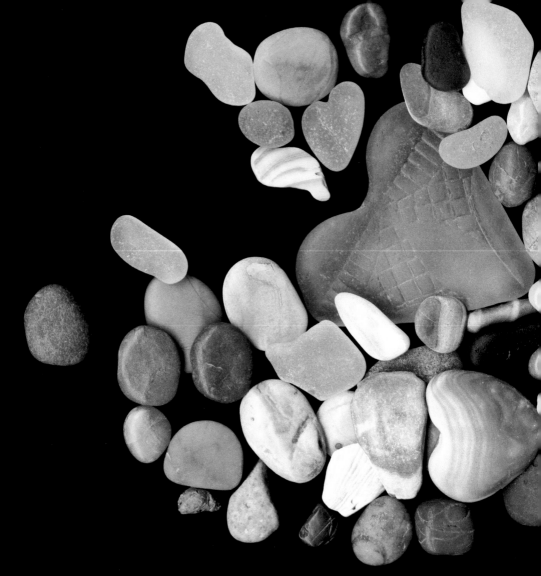

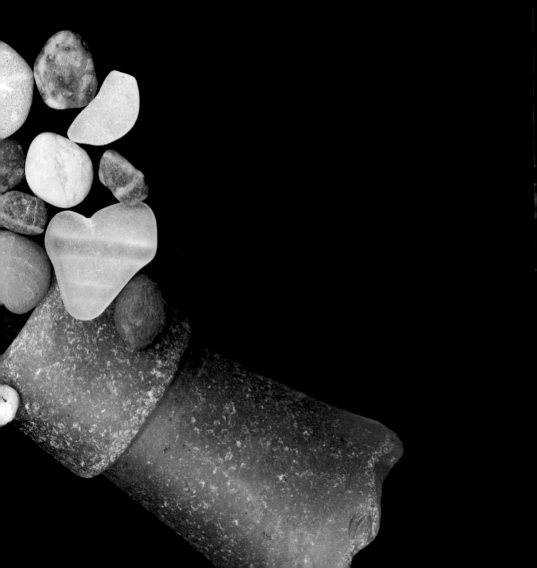

an open heart
abraded

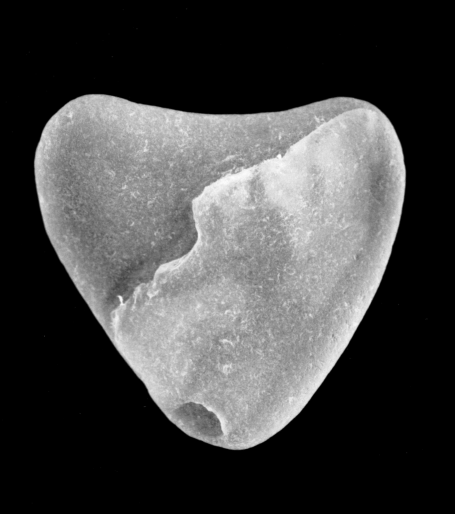

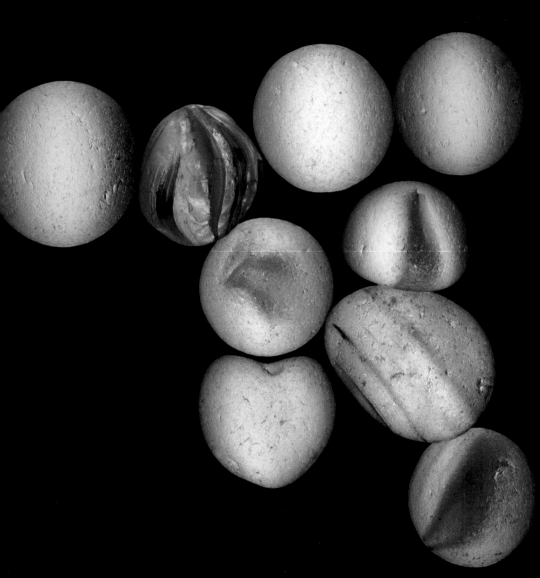

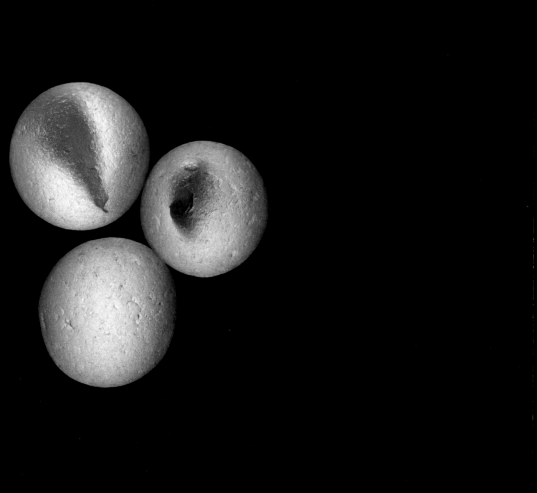

a tiny

winking

cobalt eye

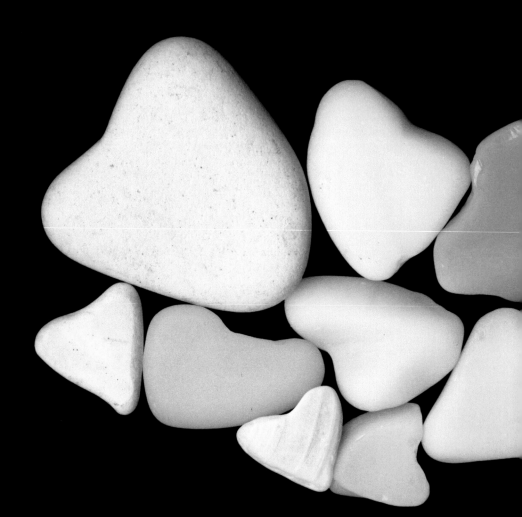

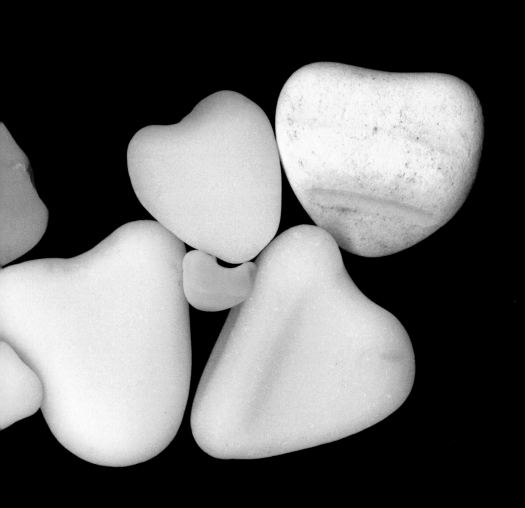

hiding in plain sight
among the chattering pebbles

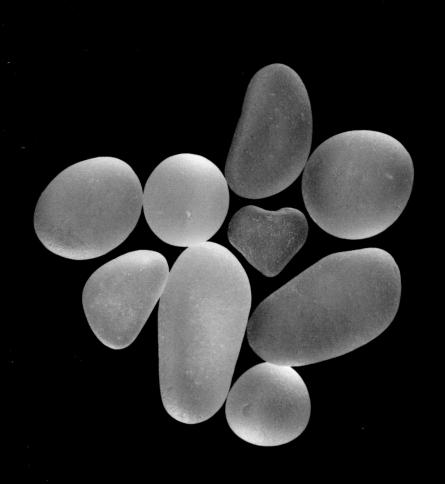

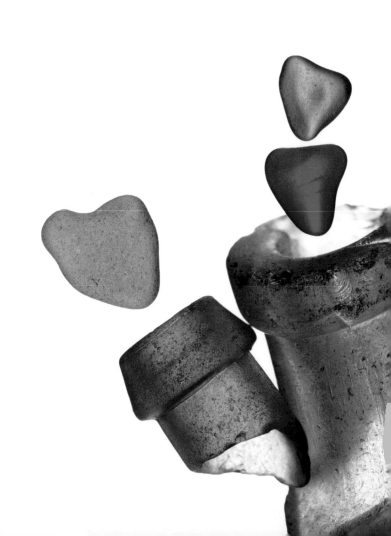

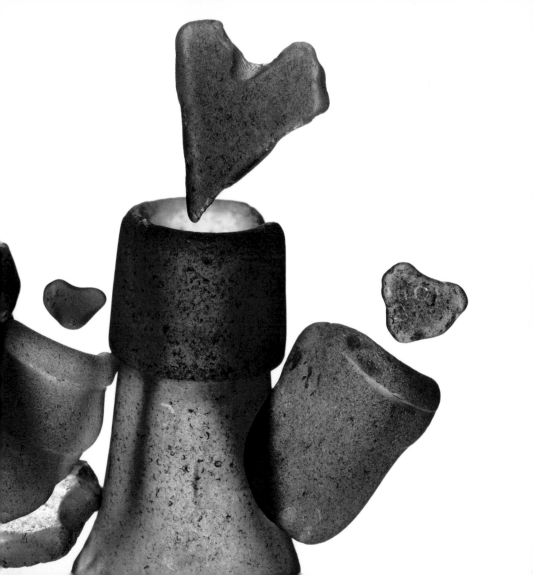

our currency of love

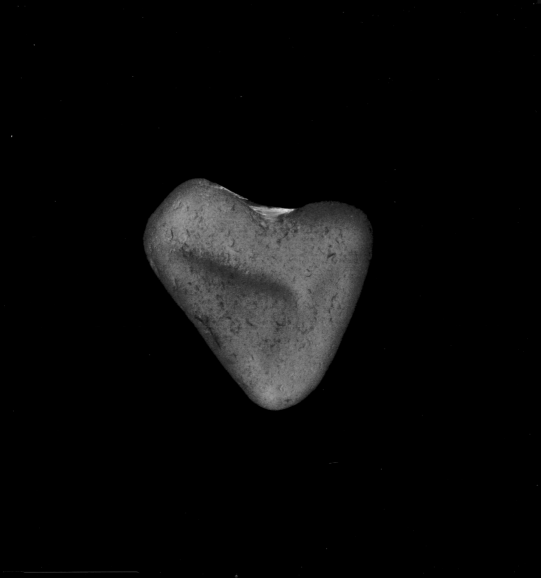

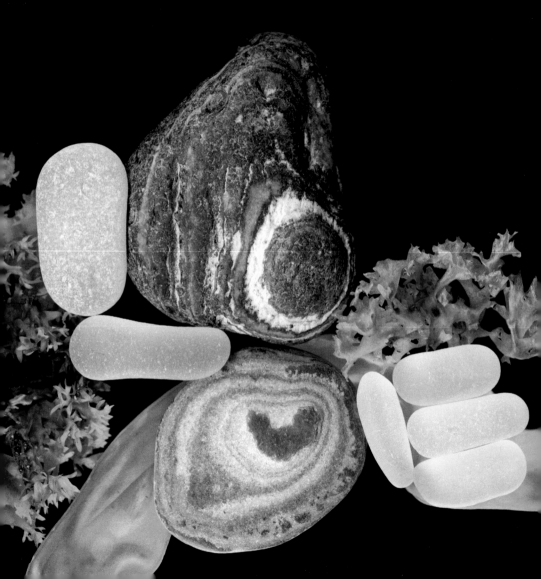

acknowledgments

These hearts celebrate our communal love affair with the beach and will, hopefully, be a reminder to give back in whatever way we can to this special zone between our land and the ocean. I have to thank Katie Carron, Kiki Kornreich, Angela MacLean, Tamie Ewing, Gail Benjamin, Cathy and Lucy Iselin, Kim and Jim Hailey, Judy Lanfranchi, Sandra Green, and Krista Hammond for sharing their treasures for this project. Their generosity of spirit infuses every page.

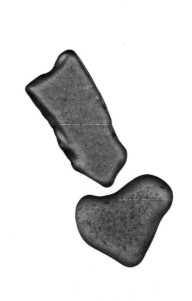

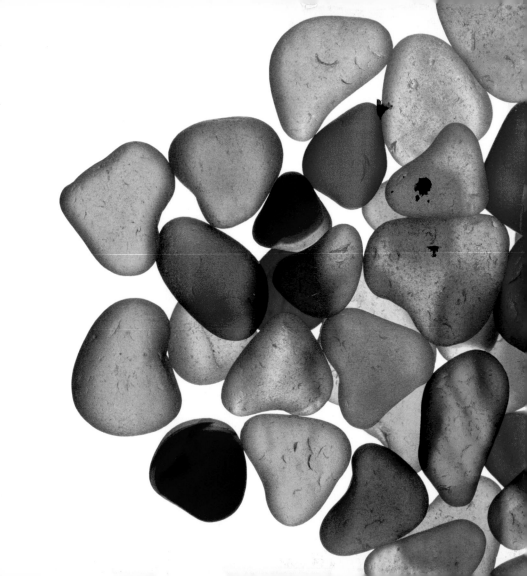